To Charlotte Rose

INTRODUCTION

Enjoy your visit to Nantucket for years to come with this treasury of images captured on the quaint and beautiful island.

Walk along the harbor, climb the church tower, and stroll around the town; head to the western end of the island and tour Madaket Harbor and some of the south side beaches. View the eastern end of the island and walk around the quaint and quintessential Siasconset. Visit two lighthouses that guided ships around the island during its rich history. These photographs provide you with a picturesque armchair journey through every corner of Nantucket.

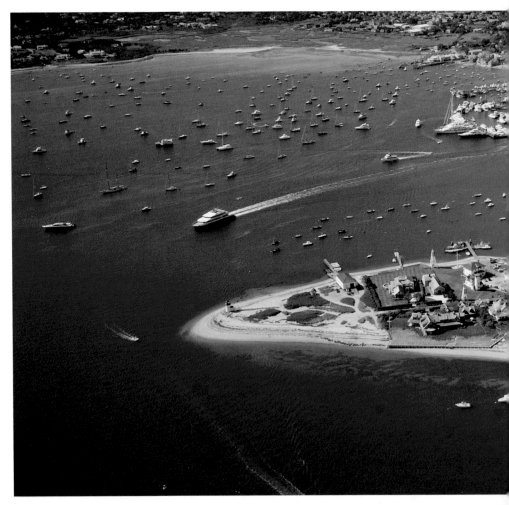

A ferry leaves Nantucket Harbor.

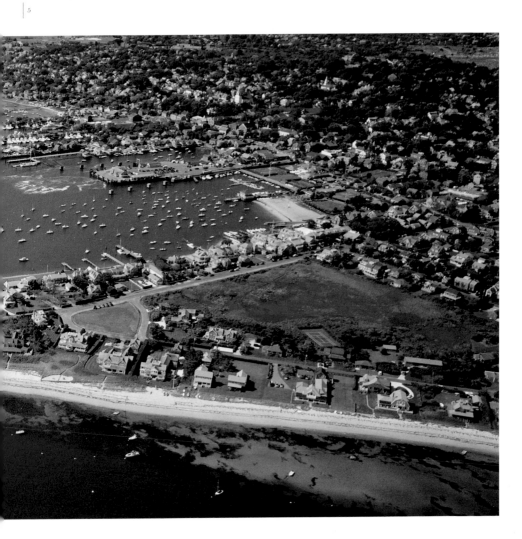

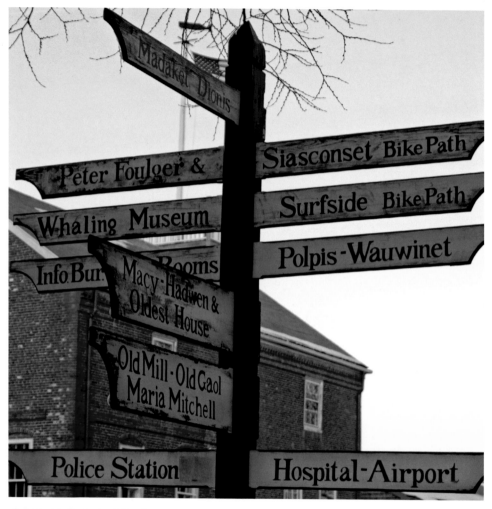

A signpost indicates local directions.

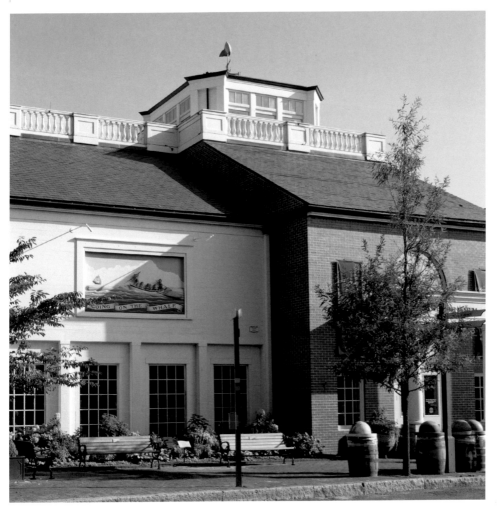

The Whaling Museum.

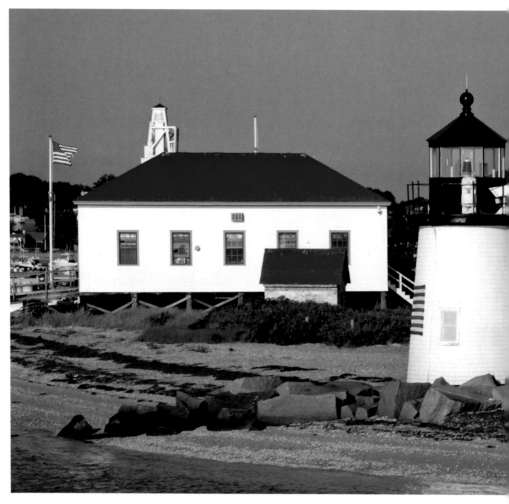

Brant Point Light welcomes visitors to Nantucket Harbor.

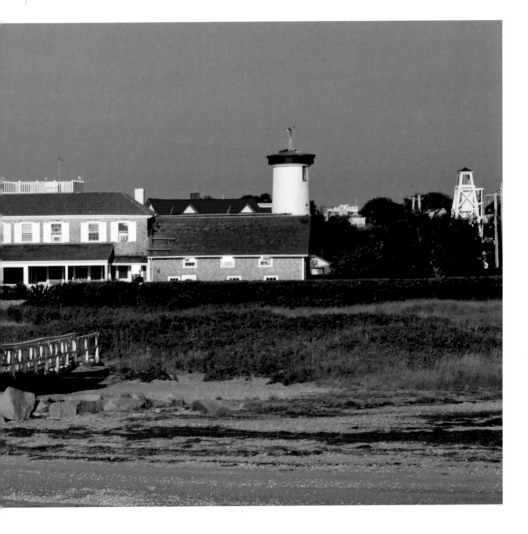

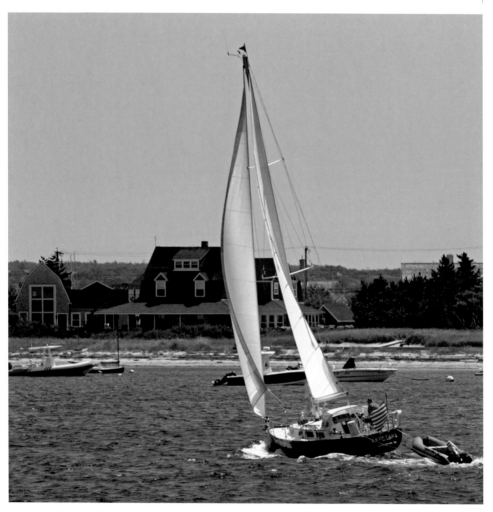

Sailing into the harbor.

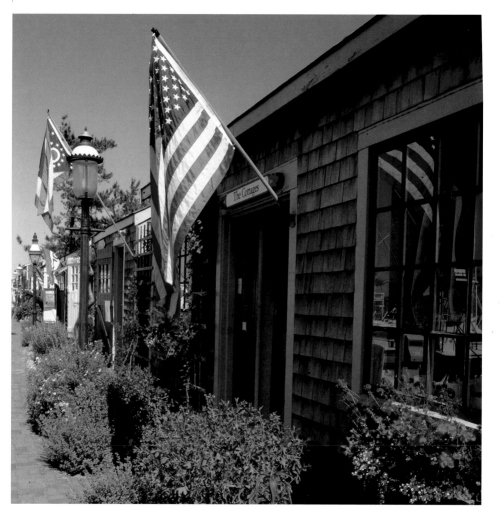

Many gift shops are near the docks.

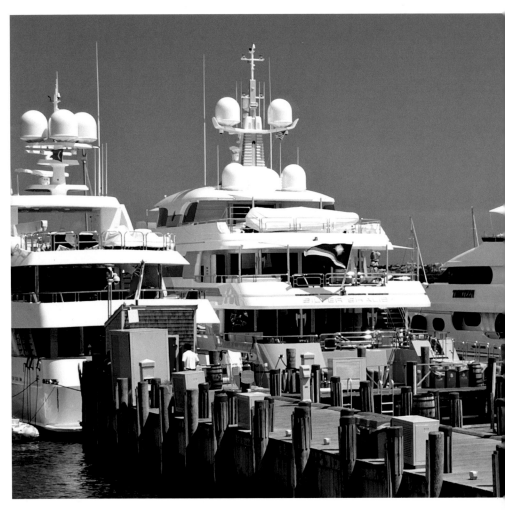

Yachts tied up to the dock.

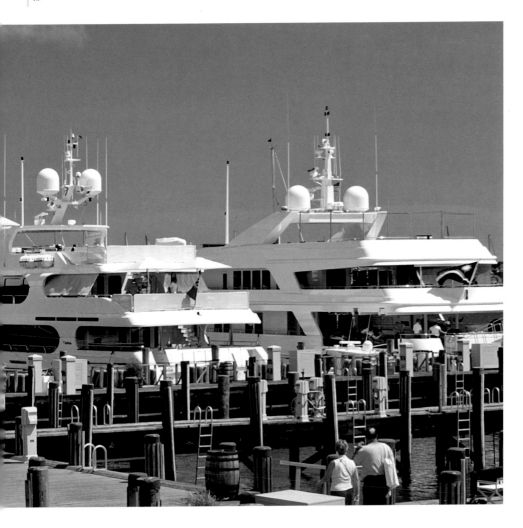

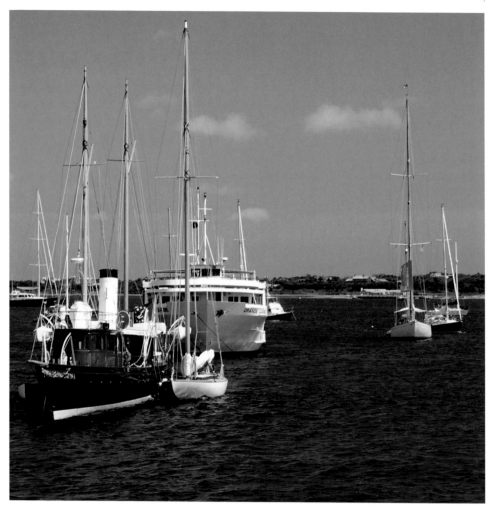

Various vessels are moored in the harbor.

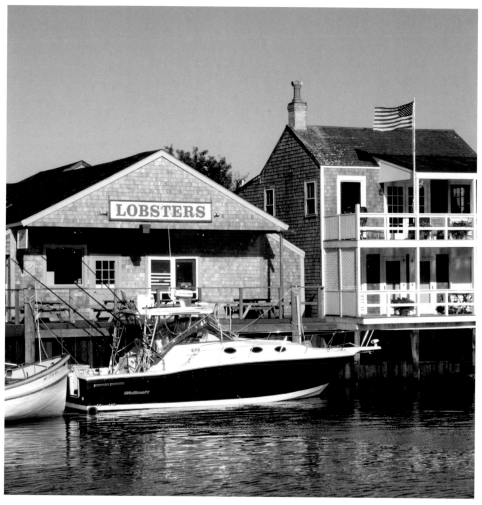

Lobsters are available for pickup by boaters.

Some wharfs date back to the time of whaling.

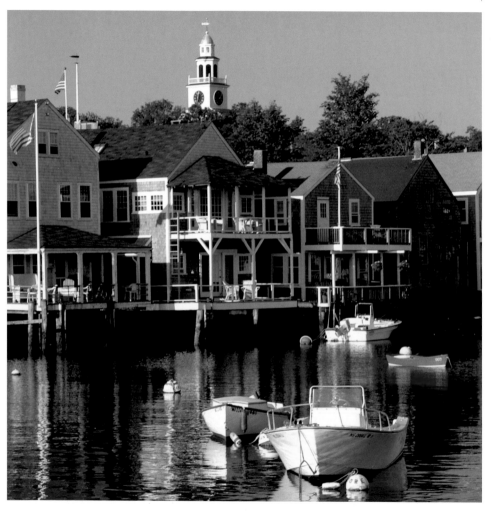

The harbor in summer . . .

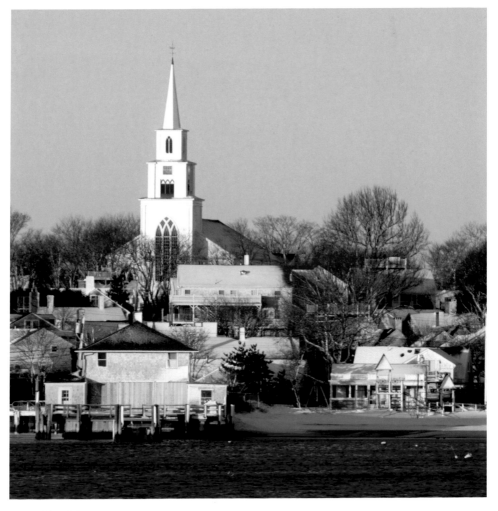

. . . and in winter.

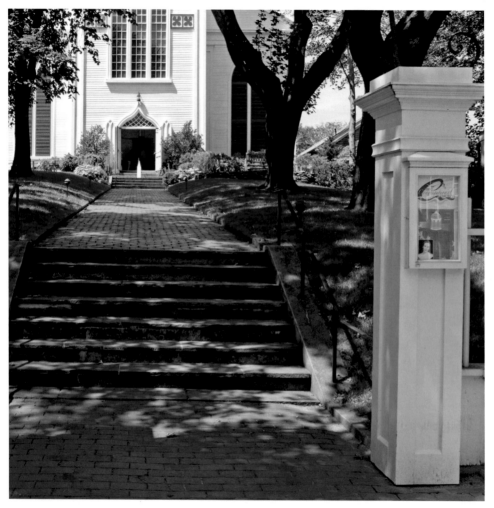

The walkway and tower of the First Congregational Church.

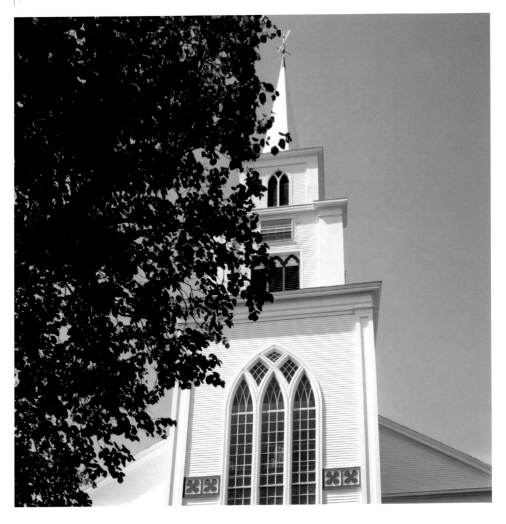

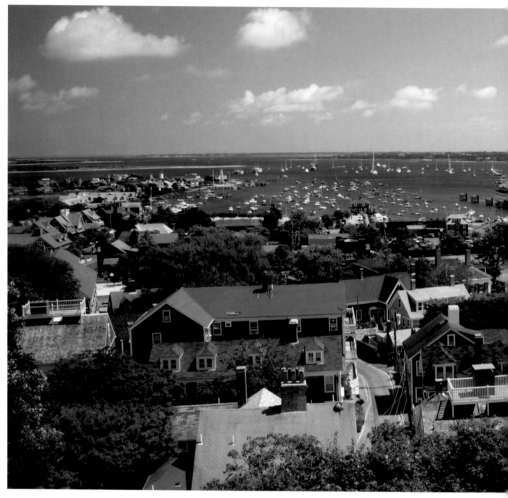

A view from the First Congregational Church tower, looking north to the harbor.

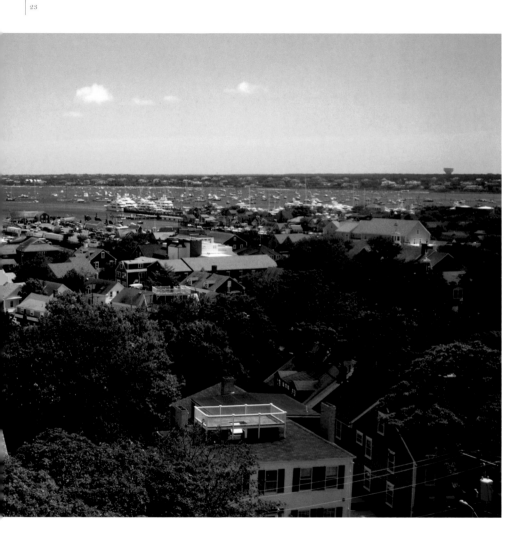

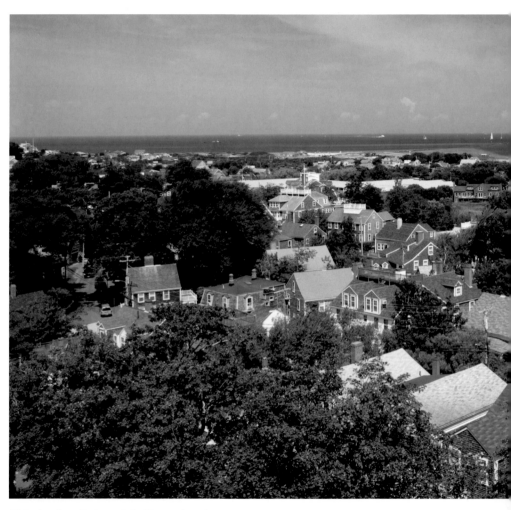

This view from the tower is looking westward.

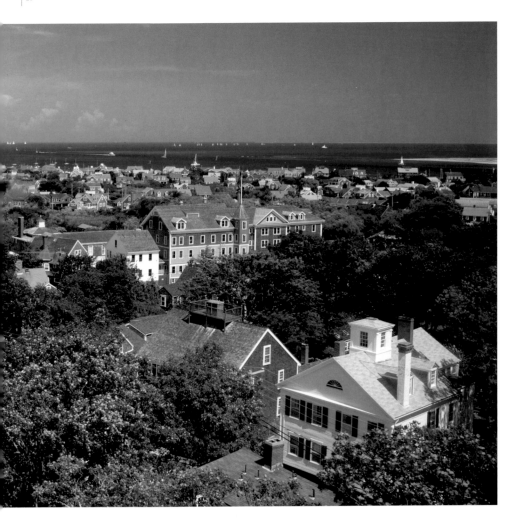

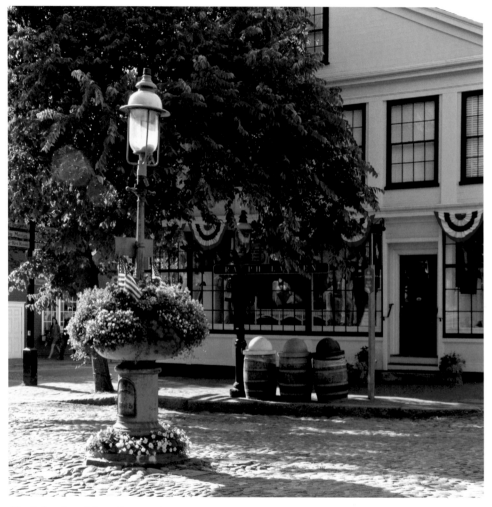

The light pole and fountain on Main Street.

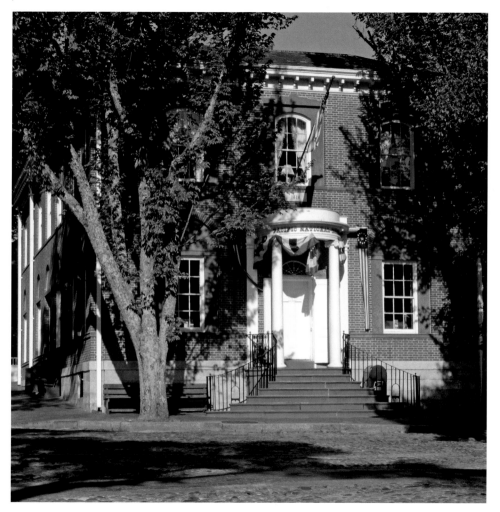

The former Pacific National Bank at the top of Main Street.

Looking up Main Street with its many shops.

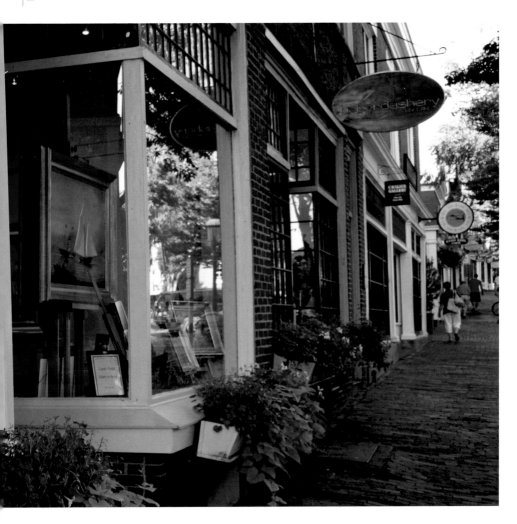

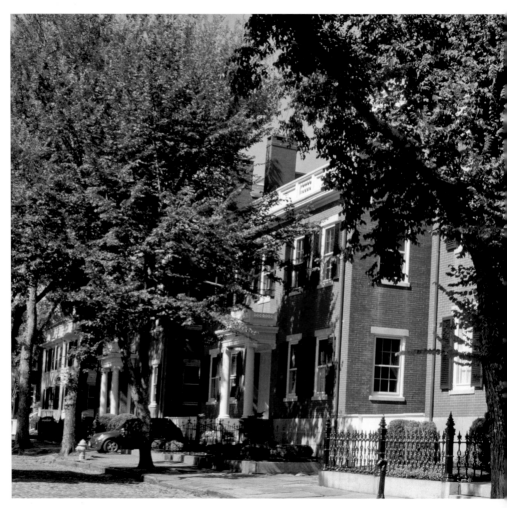

The Three Bricks on Upper Main Street.

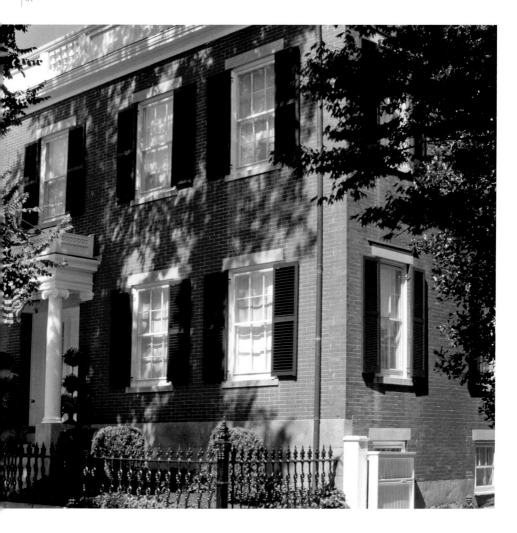

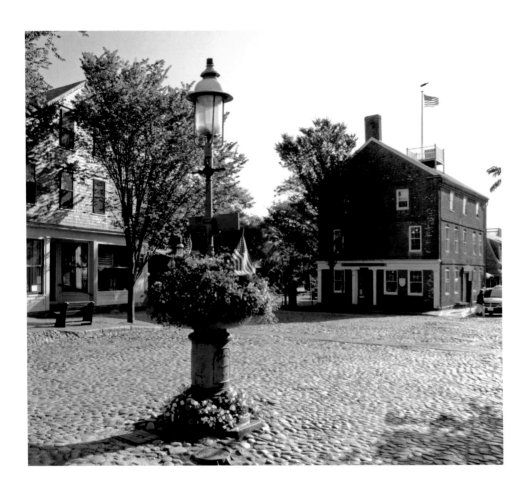

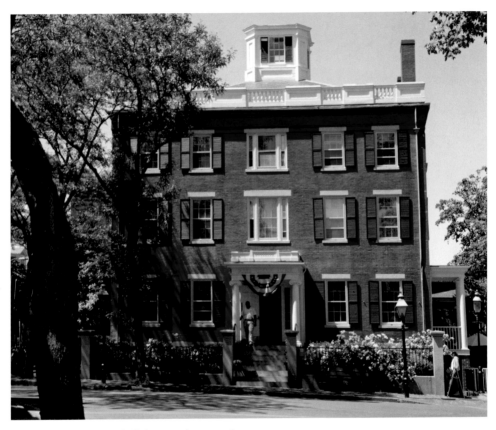

The Jared Coffin House, built in 1845, is now an inn.

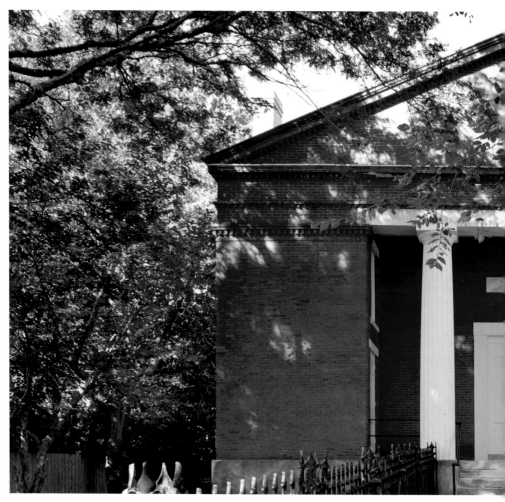

The Coffin School, erected in 1852.

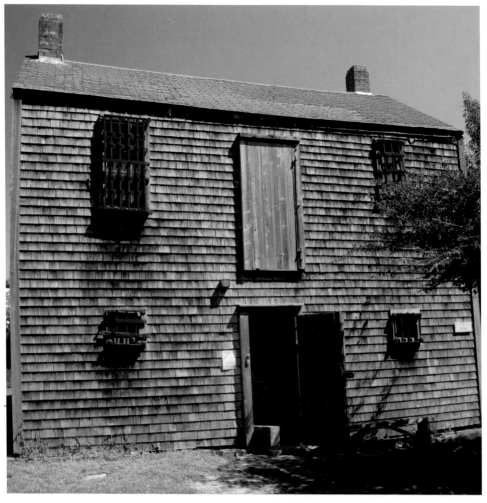

The gaol (jail) on Vestal Street is one of the oldest in America.

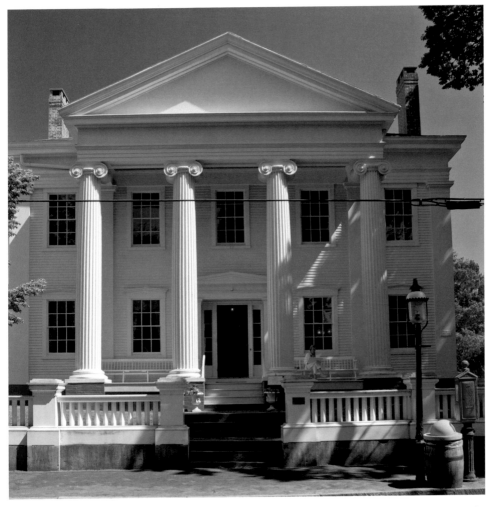

The Nantucket Atheneum houses the local library.

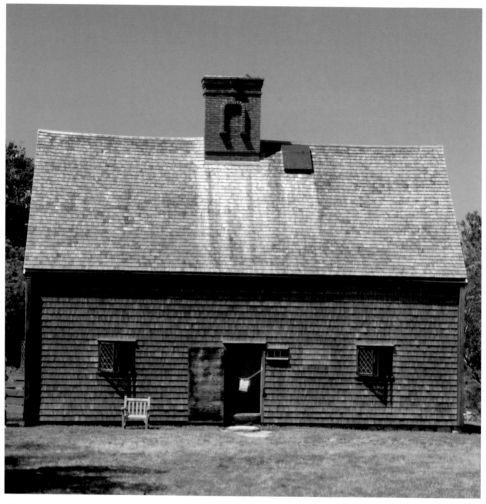

The oldest residence on Nantucket, the Jethro Coffin House, was built in 1686.

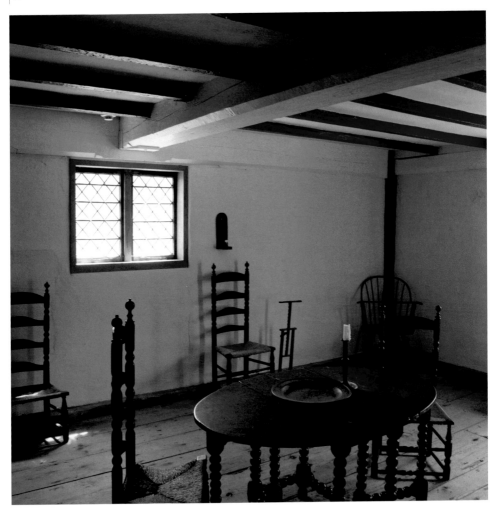

The dining area in the Jethro Coffin House.

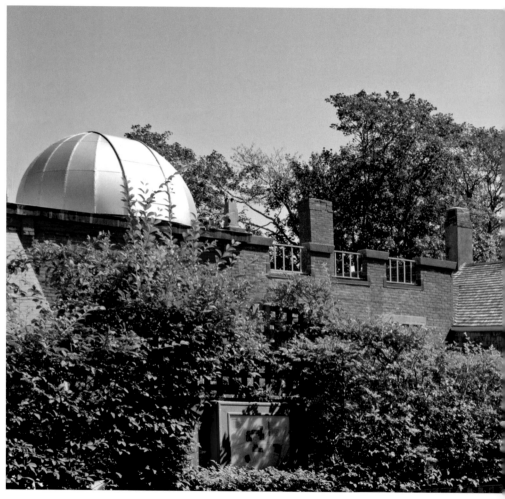

The Maria Mitchell house, built in 1790, is open for visits, as is the observatory.

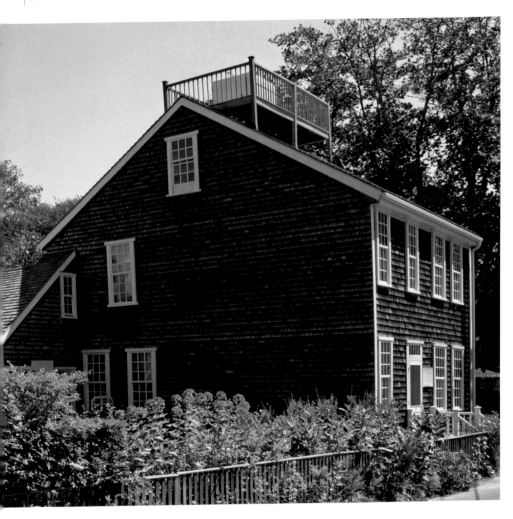

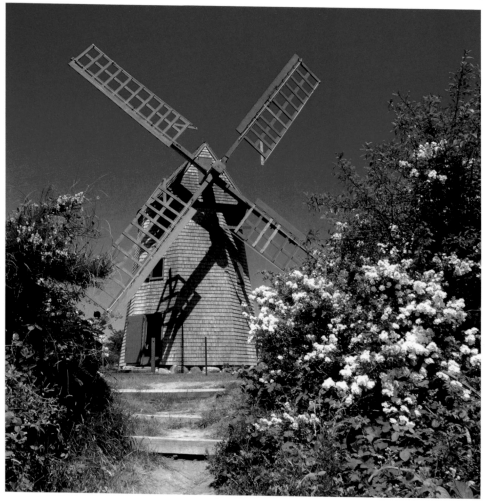

The Old Mill, built in 1746, is the oldest operating mill in the country.

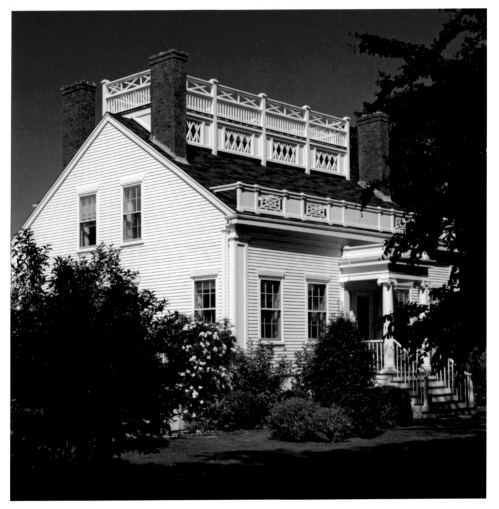

Many old houses on the island have widow's walks.

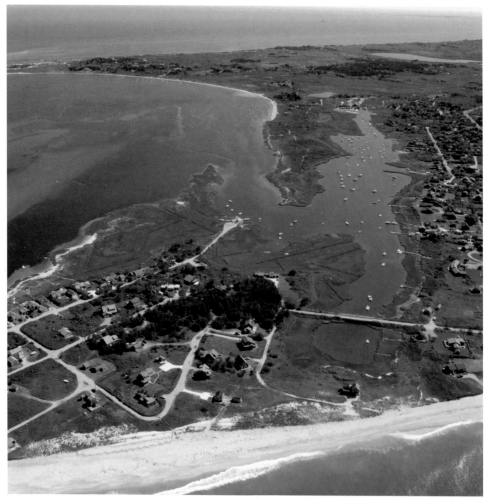

An aerial view of Madaket and Hither Creek.

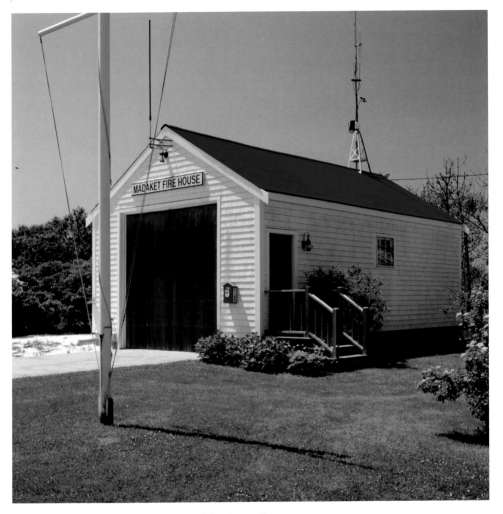

The Madaket Fire House was originally a lifesaving station.

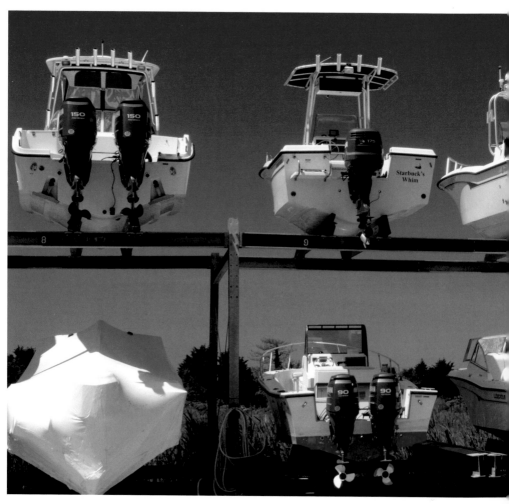

Boats stacked on racks at the harbor.

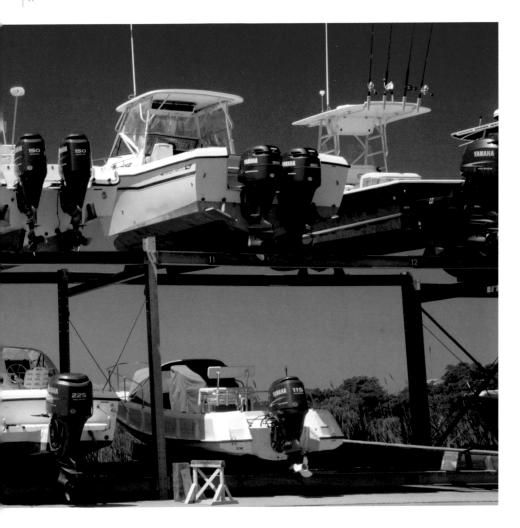

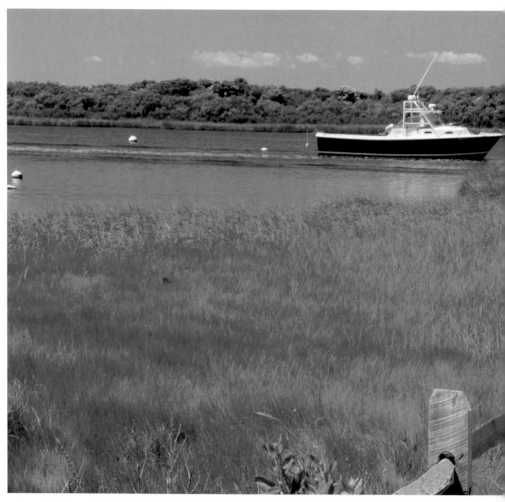

A launch area for small craft along the creek.

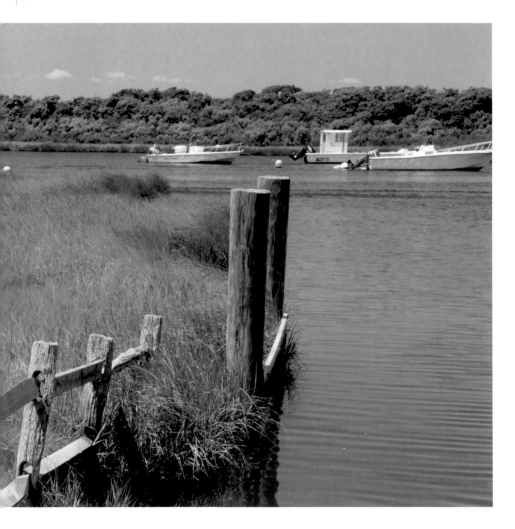

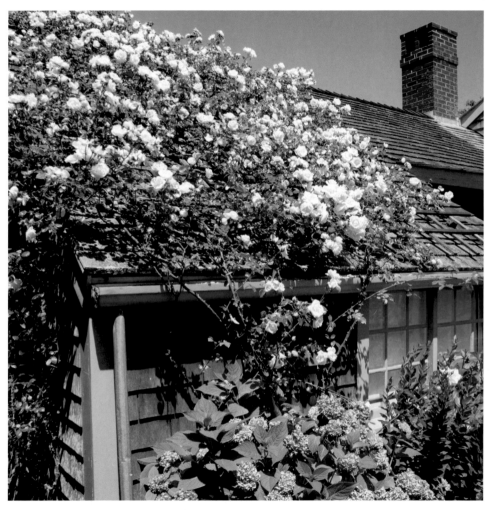

Two rose-adorned cottages in Sciasconset.

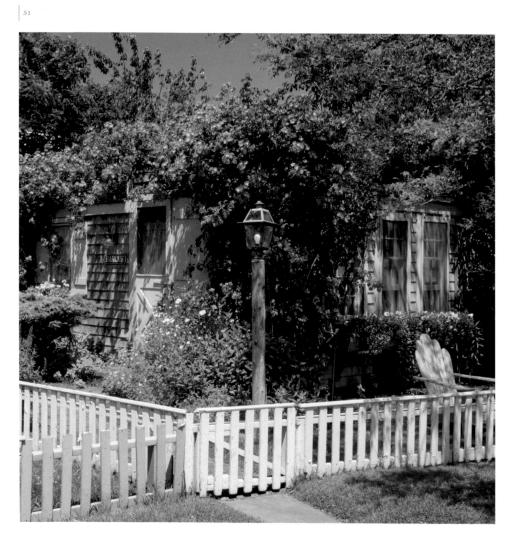

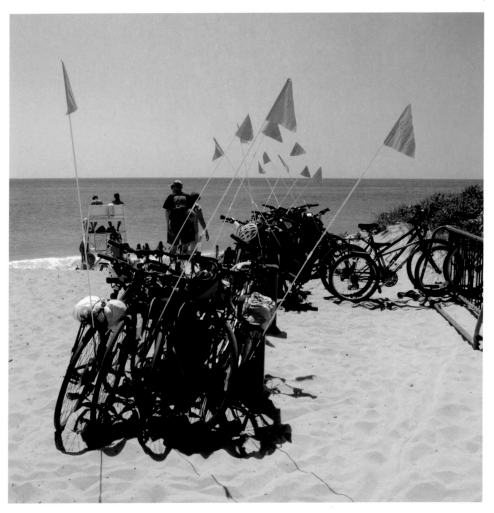

You can either ride your bike or walk on this pathway to the beach.

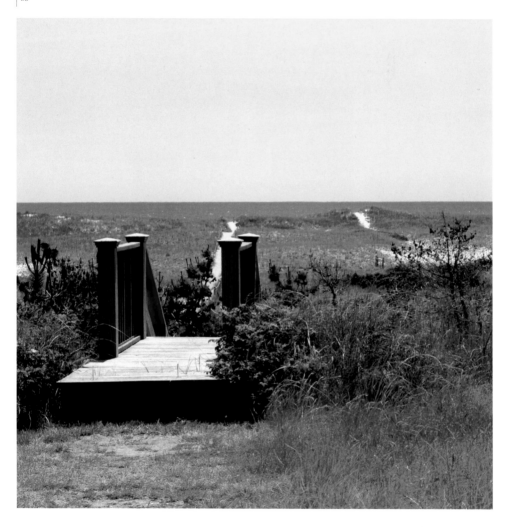

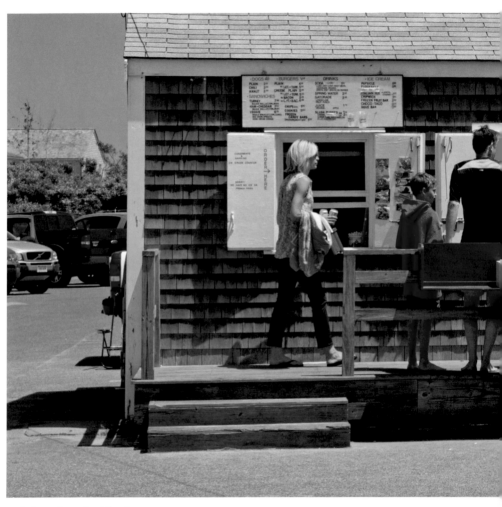

A food stand at a local beach.

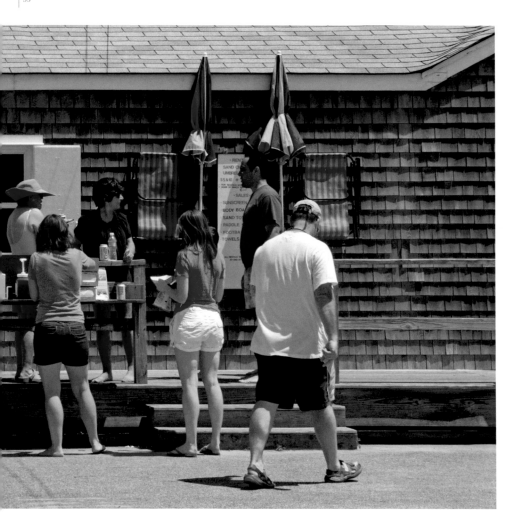

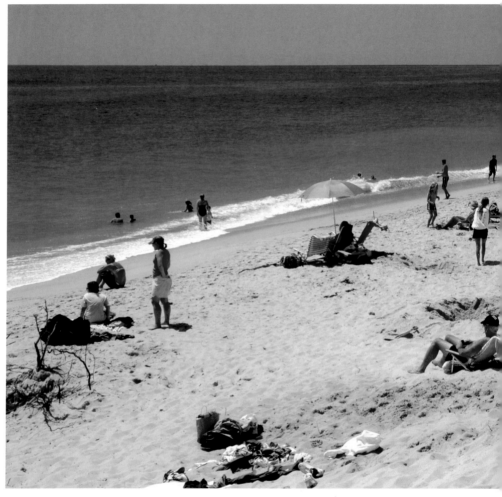

The south side of the island has many popular beaches.

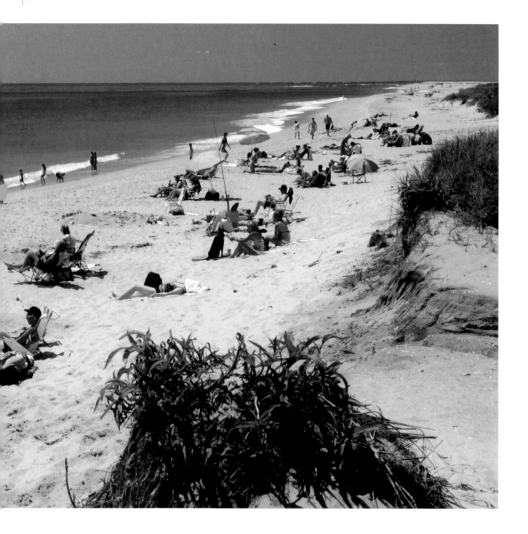

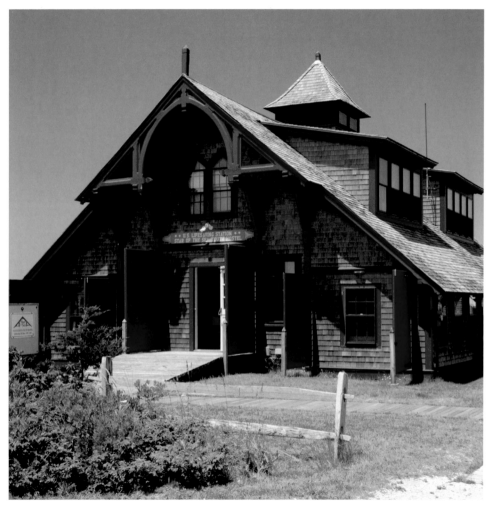

The Youth Hostel was formerly a lifesaving station.

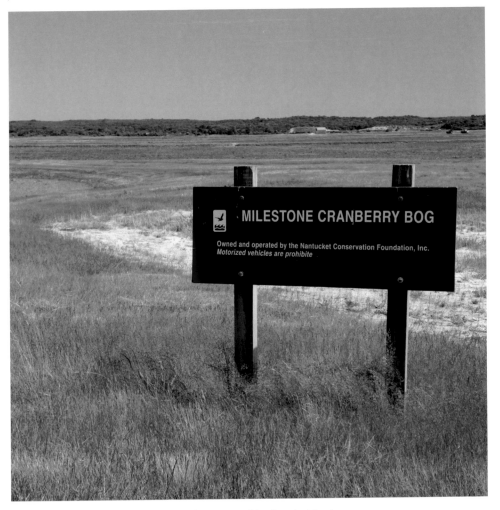

The Nantucket Conservation Foundation has preserved land on the island.

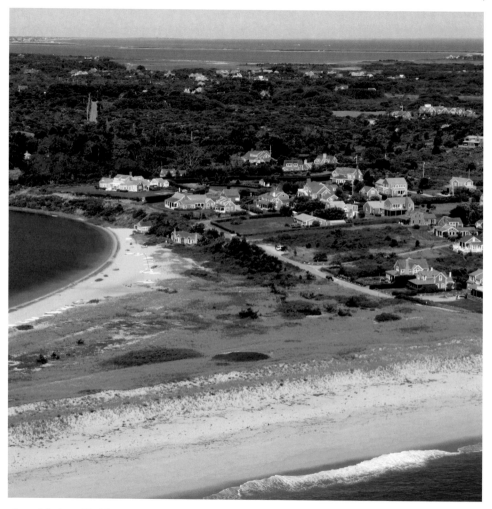

An aerial view of Quidnet, on the eastern side of the island.

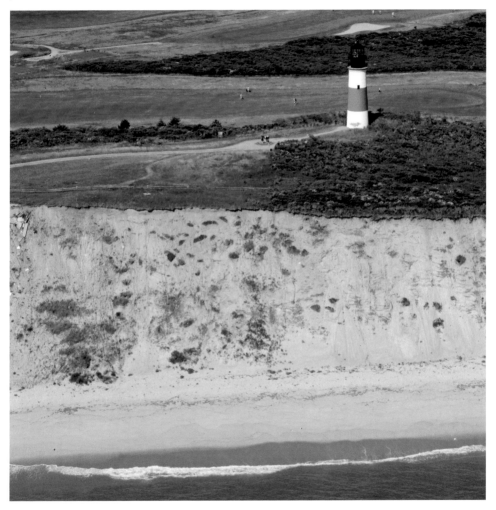

Sankaty Light on the eastern cliffs of the island.

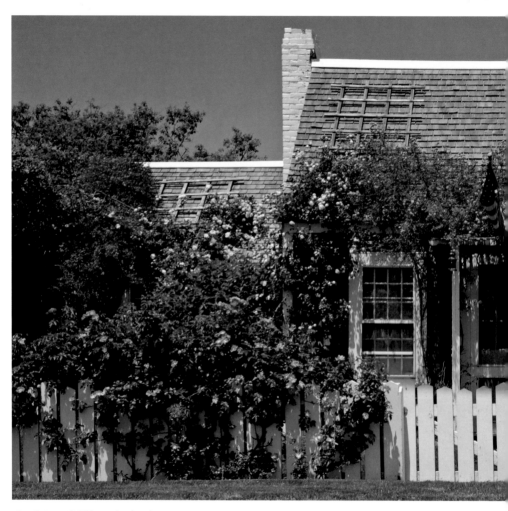

A quintessential Nantucket beach cottage.

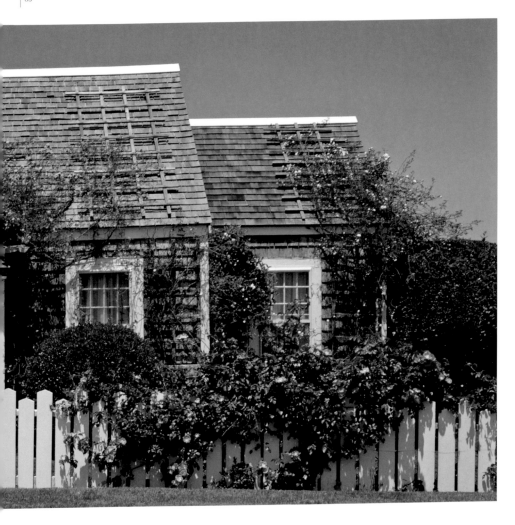

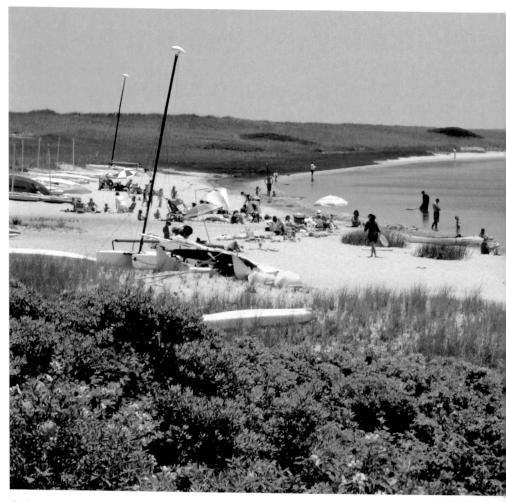

Swimmers enjoy the protected waters in Quidnet.

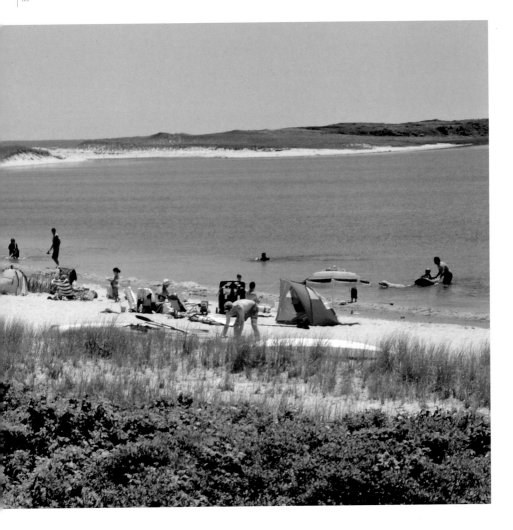

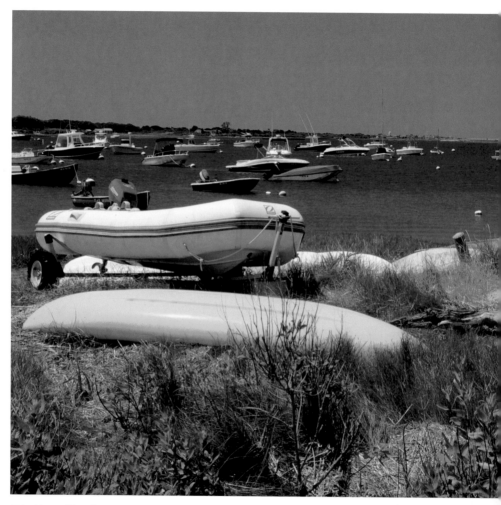

Dinghies and kayaks near a pond.

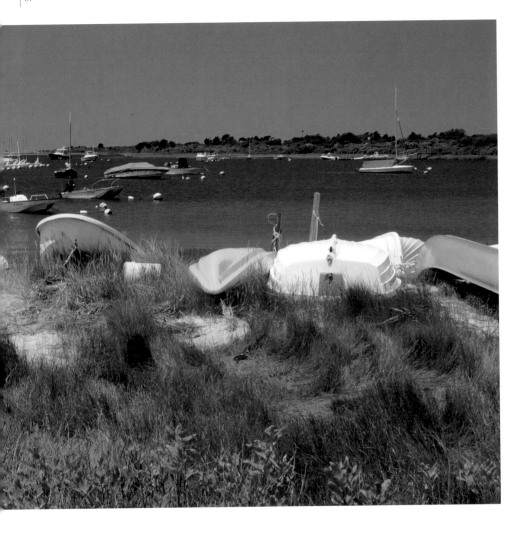

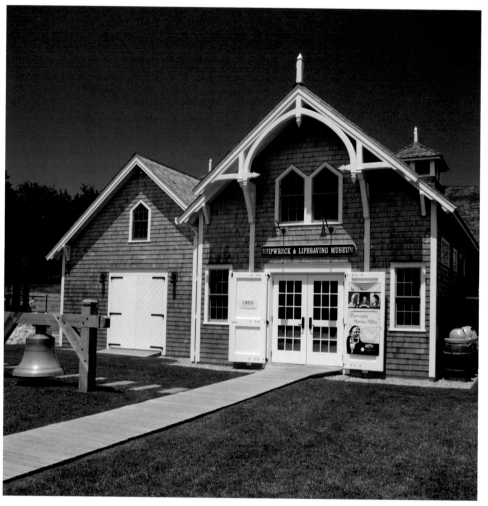

The Shipwreck and Lifesaving Museum is in Polpis.

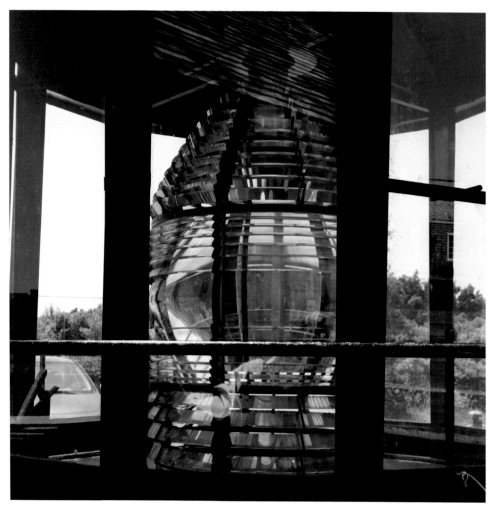

This Fresnel lens, used in a lighthouse, is on display at the museum.

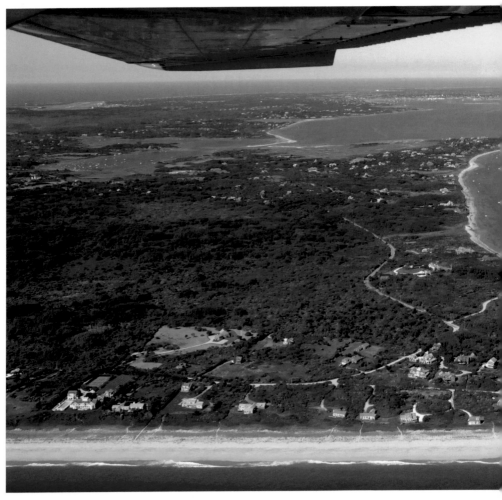

An aerial view of the eastern side of the island, with the harbor in the distance.

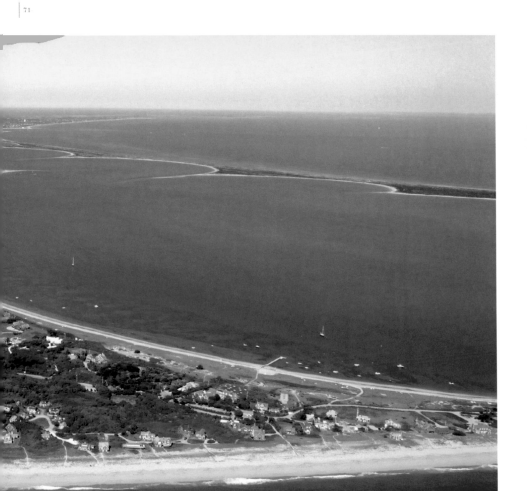

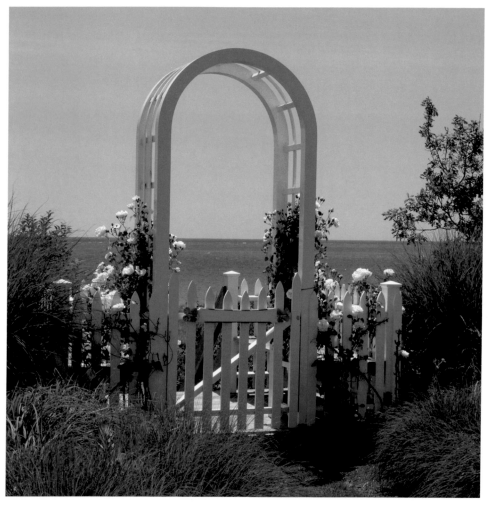

An arbor near the water.

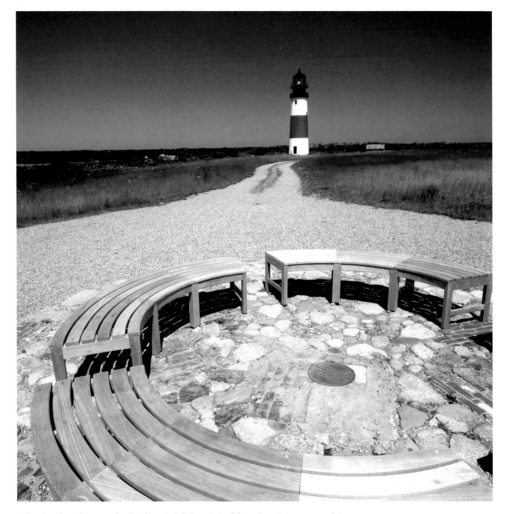

The circular plate marks Sankaty Light's original location. It was moved in 2007.

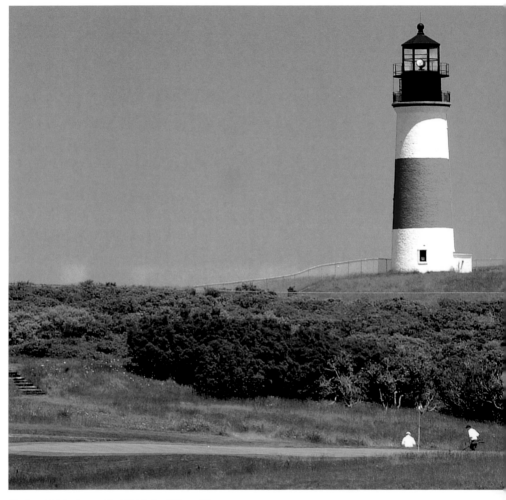

Sankaty Light is near the fifth hole of the golf course.

The beach beyond the picket fence beckons.

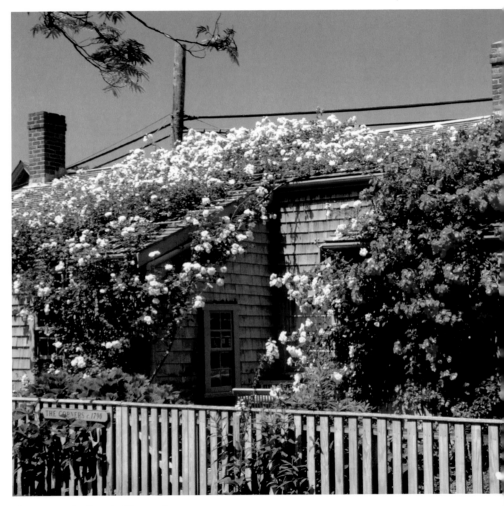

A rose-covered cottage in Siasconset.

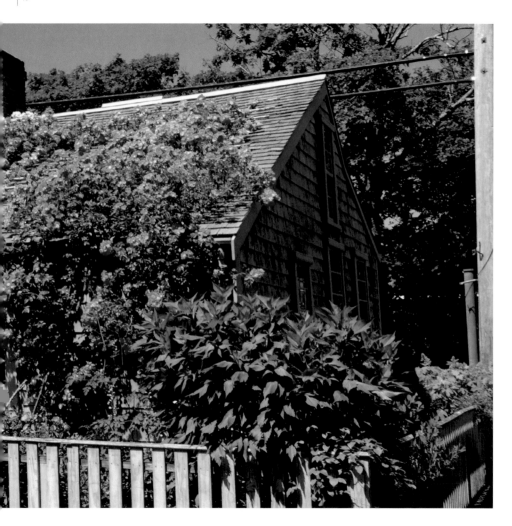

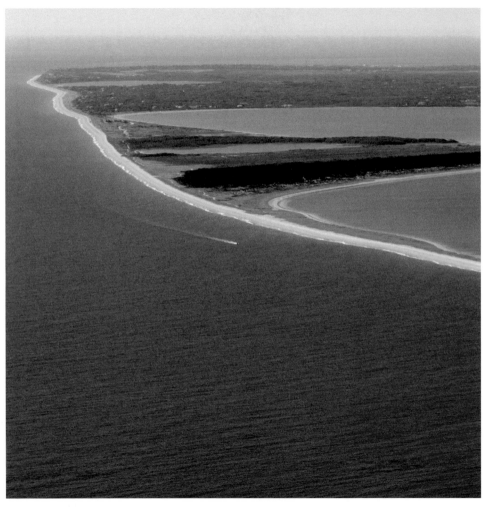

An aerial view showing the eastern side of the island.

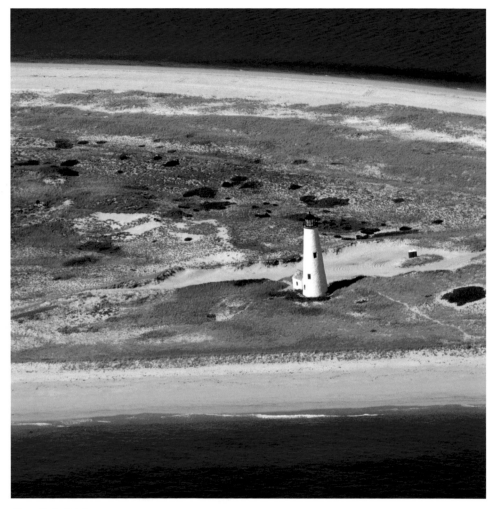

Great Point Light.

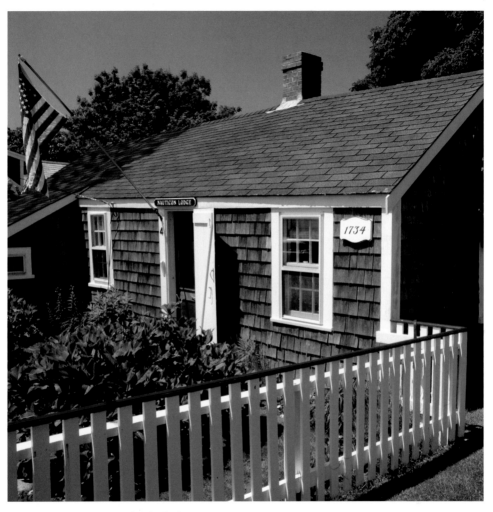

Some cottages in Siasconset date back almost 200 years.

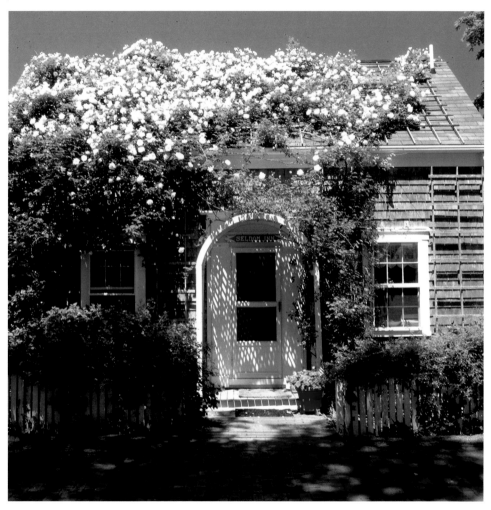

A rose-covered roof.

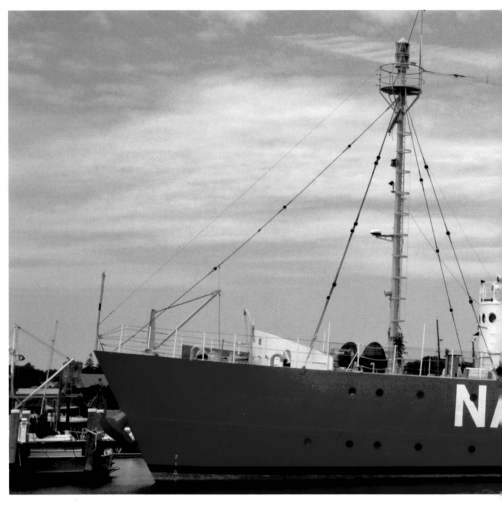

The WLV 612, one of the last two lightships assigned to Nantucket Shoals.

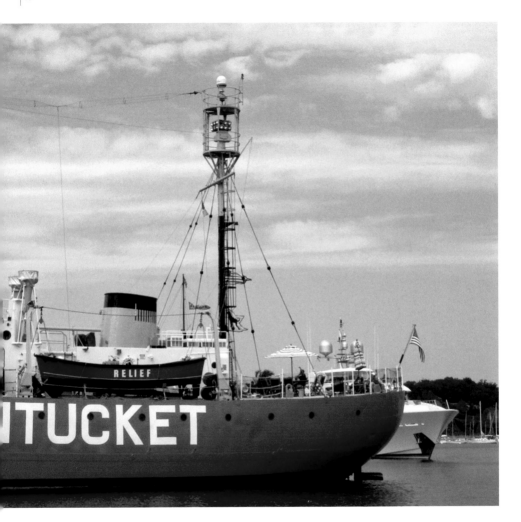

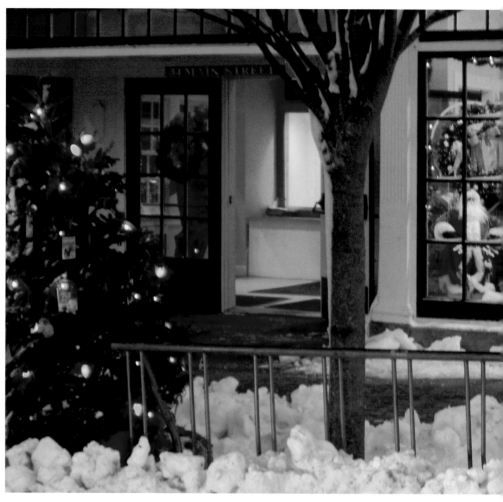

A winter street scene.

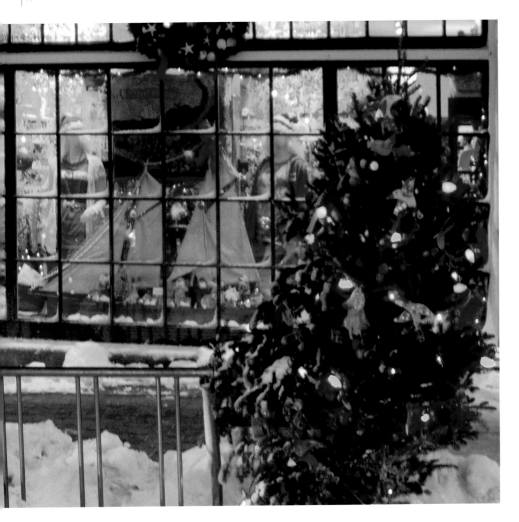

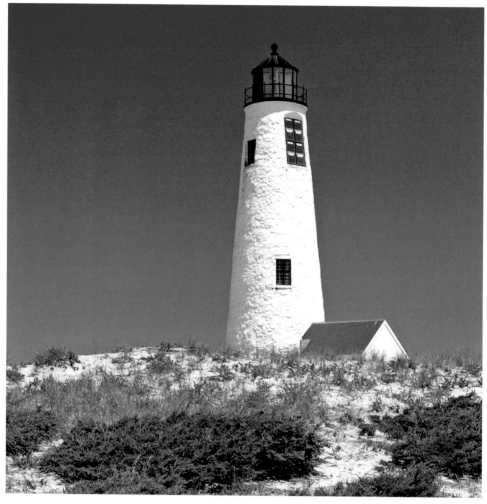

Great Point Light.

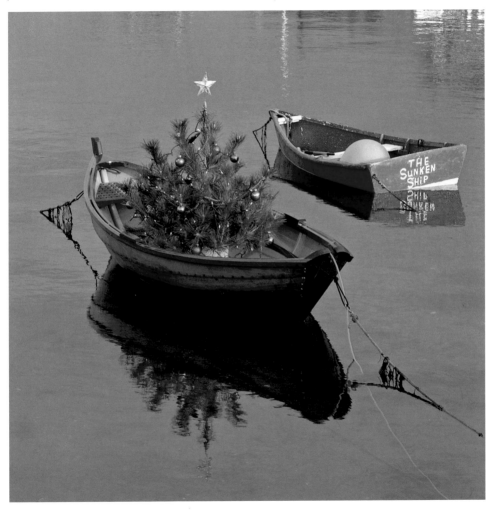

A dinghy in the harbor, decorated with a tree for the holidays.

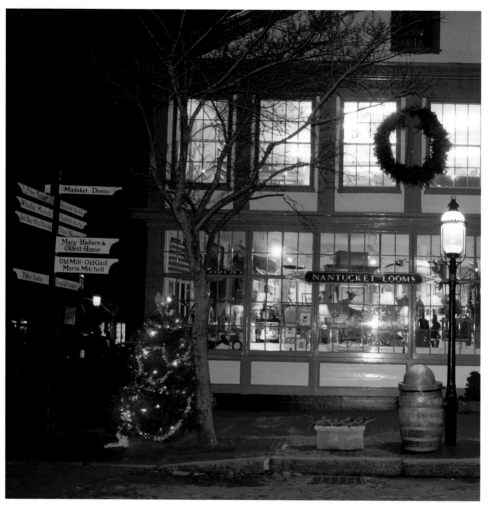

Downtown Nantucket decorated for the holidays.

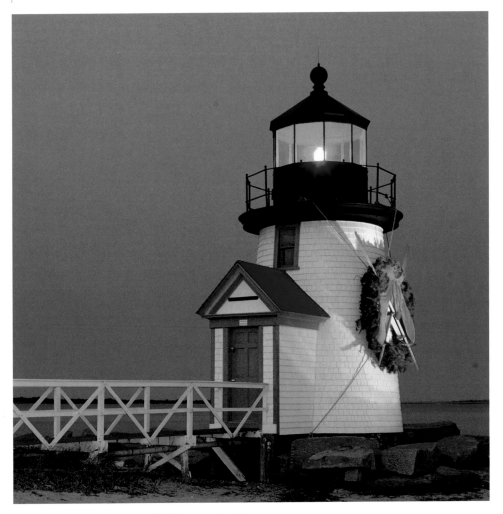

Brant Point Lighthouse sports a holiday wreath and oars.

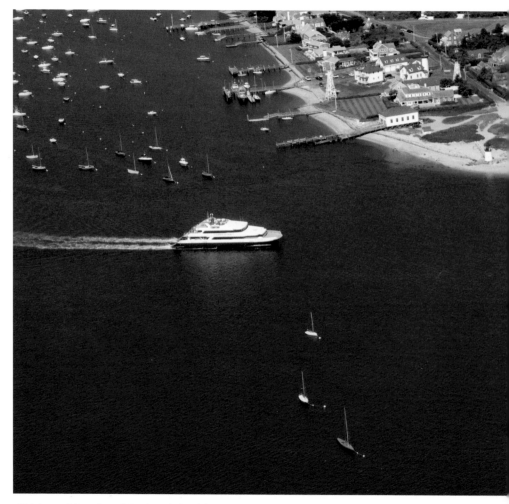

A high-speed ferry, bound for the mainland, leaves the harbor.

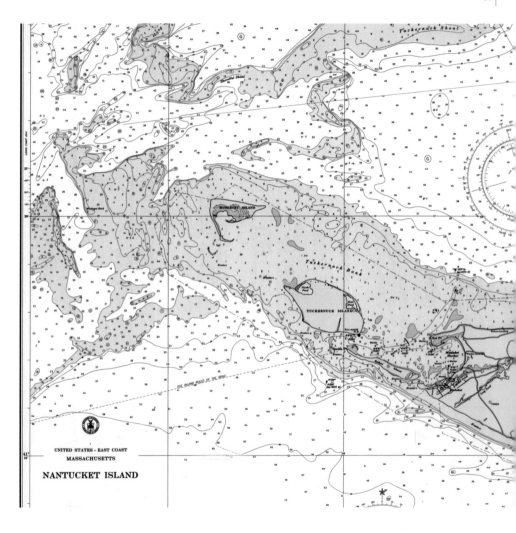

UNITED STATES - EAST COAST

MASSACHUSETTS

NANTUCKET ISLAND

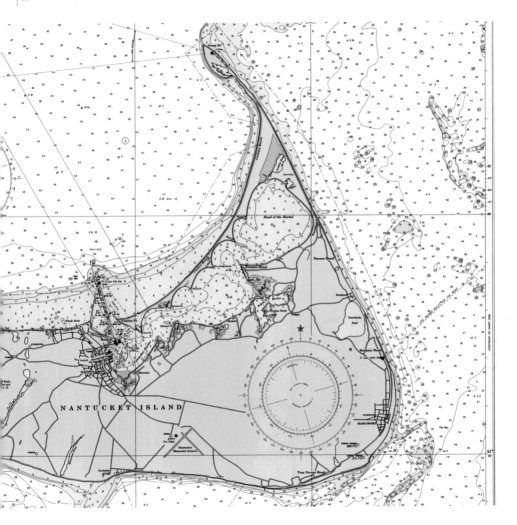

NANTUCKET ISLAND

Arthur P. Richmond has been a photographer for more than fifty years. He is the author of more than a dozen books, and his images are also found in calendars and postcards, as well as on display at several galleries in Massachusetts.

Other Schiffer Books by the Author:
Harbors of Cape Cod & the Islands,
ISBN 978-0-7643-3007-0
Lighthouses of Cape Cod & the Islands,
ISBN 978-0-7643-2460-4
Cape Cod along the Shore: A Keepsake,
ISBN 978-0-7643-5160-0

Designed by Molly Shields
Type set in Bell MT

ISBN: 978-0-7643-5159-4
Printed in China
5 4 3 2

Published by Schiffer Publishing, Ltd.
4880 Lower Valley Road
Atglen, PA 19310
Phone: (610) 593-1777; Fax: (610) 593-2002
E-mail: Info@schifferbooks.com
Web: www.schifferbooks.com

For our complete selection of fine books on this and related subjects, please visit our website at www.schifferbooks.com. You may also write for a free catalog.

Schiffer Publishing's titles are available at special discounts for bulk purchases for sales promotions or premiums. Special editions, including personalized covers, corporate imprints, and excerpts, can be created in large quantities for special needs. For more information, contact the publisher.

We are always looking for people to write books on new and related subjects. If you have an idea for a book, please contact us at proposals@schifferbooks.com.